LIGHT, SHADE AND SHADOW

LIGHT, SHADE AND SHADOW

E. L. KOLLER

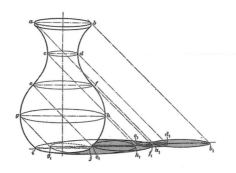

DOVER PUBLICATIONS, INC.
Mineola, New York

Bibliographical Note

This Dover edition, first published in 2008, is an unabridged republication of *Light and Shade Prepared Especially for Home Study,* originally published by International Textbook Company, Scranton, Pennsylvania, in 1937. The book was first published in 1914.

International Standard Book Number
ISBN-13: 978-0-486-46885-3
ISBN-10: 0-486-46885-2

Manufactured in the United States of America
Dover Publications, Inc., 31 East 2nd Street, Mineola, N.Y. 11501

PURPOSE

1. Three Stages in Learning to Draw.—The first stage in learning to draw is limbering up the arm, wrist, hand, and finger muscles and practicing line drawing and eye measurement. The second stage is making drawings in outline direct from objects and models, to familiarize the beginner with form and proportion in three dimensions; length, breadth, and thickness. The third stage, in logical order, is the portrayal of these objects or models pictorially. This means drawing these objects so that the light parts, the shaded parts, and the shadows that are cast, are properly expressed, not only in their forms and contours but also in their correct tone values.

This requires a thorough knowledge of the principles governing light, shade, and the casting of shadows, as well as a training in rendering drawings; that is, in portraying them pictorially. These principles can best be illustrated by placing the wooden models, used when making the outline drawings, in various positions and having the light fall upon them from certain directions, and then studying the light, shade, and shadow effects, and can best be applied by making drawings direct from the wooden models. This plan will be employed in this Section.

These light, shade, and shadow effects, as observed on the simple geometric solids employed, will serve as a foundation knowledge of how to portray lights, shades, and shadows when the objects employed are more complicated, as human figures, etc. For this reason this study of light, shade, and shadow values must not be looked on as being too elementary, but as a necessary foundation for successful pictorial or decorative work.

LIGHT, SHADE, AND SHADOW

SOURCES AND KINDS OF ILLUMINATION

2. Main Sources of Light.—An examination of the wooden models will at once show that there are no absolute outlines in nature. The forms are expressed by various planes of light and shade coming together and the edges of these are seen simply because one plane is of a different tone value, that is, lighter or darker, than its neighbor. The values of these various planes are determined by the kind, the source, and the direction of the illumination that the objects receive.

Broadly considered, there are two general sources of light: *sunlight*, in which the rays of light are parallel, and *artificial light*, in which the rays of light come from a point and diverge.

The sunlight may be direct or indirect. The object may be directly in the path of the sun's rays and thus be brilliantly lighted and cast clear distinct shadows; or it may simply receive light from a window that admits the reflected light from the outside lighted air; that is, the direct rays of the sun do not fall upon the object.

The artificial light may be of many kinds; from an arc or incandescent electric lamp, from a gas flame or burner, or from an oil lamp, a candle, an open-hearth fire, etc.

3. Kinds of Illumination.—Both sources of illumination may light up the objects in many ways. When the light is obtained from a number of directions at once, as from several windows or widely separated lamps, the illumination is known as *diffused lighting*.

When the source of light is in front of an object, so that the nearer parts of the object are lighted and the back is in shade, the illumination is known as *front lighting*.

2

When the source of light is behind an object, so that the back is lighted and the front is in shade, the illumination is known as *rear lighting*.

When the source of light is overhead, so that the tops of the objects are lighted, the illumination is known as *overhead lighting*.

When the source of light is on one side, so that the side of the object nearest the light is most brilliantly lighted and the

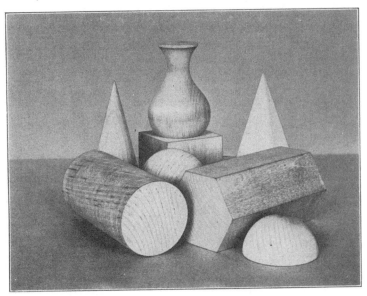

FIG. 1

opposite side is in shade, the illumination is known as *side lighting*.

When the source of light is on the left side of and above the object, the illumination is known as *conventional lighting*.

The different kinds of illumination are here shown by means of photographs of the wooden models, but the actual effects caused by the different sources and directions of the light can best be studied by observing the results produced on the models when placed, singly and in groups, in every possible position.

4. Diffused Lighting.—In Fig. 1 are shown the effects produced by ordinary diffused lighting on the group of models. This is the effect that is produced when the models are placed on a table in a room well lighted by three or four windows; that is, with the light coming from three or four (or more) directions at one time. In this case, the light comes mostly from the front and sides but not from the back and there has been no particular effort made to secure interesting lights and shades. This group is introduced merely to show a typical condition of lighting, but reveals very little that would be clear enough to enable one to formulate principles of light and shade. No gradations of light and shade are shown, neither are there any well-marked shadows. This is due to the fact that the light comes from many sources and kills the greater portion of the shadows. For instance, the typical shadows might be cast toward the right by the light coming from the left, but as light is coming also from the right and from the front these latter rays shine in upon the shadows and, to a great degree, dispel them. Therefore, what little shadow is shown is directly under or very close to the object casting it, and it is very soft or blurred on the edges. The texture, that is the grain, of the wood of the models is beautifully revealed, thus showing that the lighting is clear and adequate.

It will be observed that, as a group, this effect of lighting is flat, monotonous, and far from pleasing, although it is perfectly natural and typical. The importance, therefore, of securing a method of lighting that will bring out properly the light, shade, and shadow effects is quite evident.

5. Front Lighting.—Fig. 2 shows the group of models lighted by direct sunlight coming from back of the observer and shining onto the front of the objects. The effects of surface lighting are interesting when comparison is made, object for object with the same group conventionally lighted, as in Fig. 5. On all the objects, deep shade is absent, because the strong front light dispels it, but a sort of half shade is noticeable on parts of each model. The high lights on all

rounded surfaces tend to approach more nearly the center line instead of the left-hand contour of the object. If the models were of polished metal, the extremely brilliant points and lines of brightest high light would be clearly shown.

The shadows are clear and distinct, but little of them is seen because they are all cast back of the objects. However, should this group of models be looked at from above, the retreating shadows would be plainly seen.

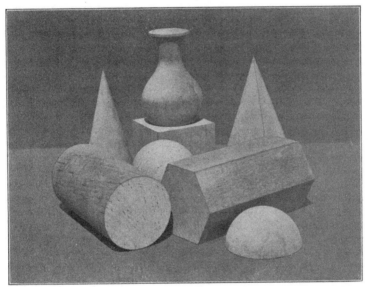

FIG. 2

6. Rear Lighting.—The conditions of lighting for the group shown in Fig. 3 are exactly the reverse of those used for the group shown in Fig. 2, because the objects are lighted from the rear. As the light rays come toward the observer, they illuminate the backs of the models, put into deep shade the fronts of the objects, and cast dark, distinct shadows toward the observer. The most noticeable feature about this group is that, at first glance, it appears composed of black objects, with very little modeling, casting black shadows. Closer examination, however, reveals the modeling of each

object, although largely in shade. With the exception of the top face of the hexagonal prism, which reflects the light rays perfectly, no high lights occur, although a few half lights are shown, as on the tops of the cylinder, the sphere, and the hemisphere. The soft graded lights on each side contour of the vase are beautiful examples of reflected light falling onto an object. The gradation of values from half light to half shade, and then from half shade to deep shade, as shown on

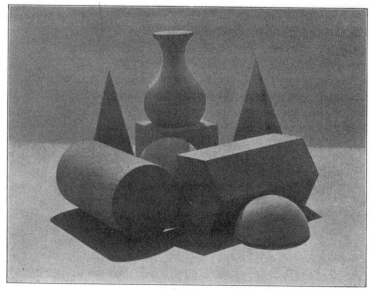

FIG. 3

the hemisphere, is worth careful study. The shadows are, of course, blacker than any of the deep shades, although careful observation is required to detect this at places. All shadows are cast toward the observer.

7. Overhead Lighting.—When the models are lighted from above, as in Fig. 4, the most noticeable features are the bright lights on the tops of the objects and the dark shades at the bottom, the shadows being cast under the objects. In this way, high light, half tone, and shade are expressed,

as in the case of the objects conventionally lighted, but from top to bottom, instead of from upper left to lower right. For instance, the high light on the sphere is exactly at the top and the half tone, if it could be seen, around the lower half, the shade being at the bottom. This is well illustrated by the lower part of the vase, which is practically a sphere. The very bright high light on the flat top of the vase shows very clearly the source of the light.

The shadows naturally have little extent beyond the limits

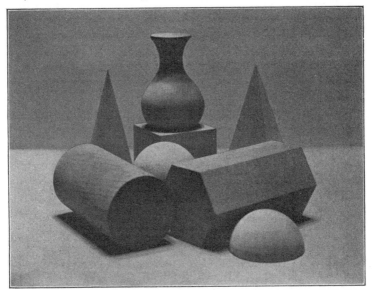

FIG. 4

of the objects themselves. The peculiar blurred effect of the edges of the shadows is due to the fact that, when the photograph was taken, the group was lighted from an overhead electric chandelier in which there were four or more lamps, each casting a shadow.

8. **Conventional Lighting.**—In Fig. 5 is shown the effect of having the models lighted from the side and in front, and slightly above, thus casting the rays of light down upon the object at an angle of about 45°; that is, so that the shadow

is about the same length as the height of the object casting it.
The system of conventional lighting has been agreed on as
a standard that may be used when formulating theories of
light, shade, and shadow casting. It will be noted that the
shadows are sharper and more readily traced, and the con-
trasts of light and shade clearer, than under any other con-
dition of lighting.

The cylinder, the hexagonal prism, and the hemisphere
are shown in horizontal positions, and the light effects on

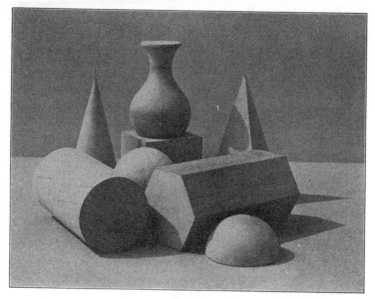

FIG. 5

them and the forms of their shadows should be carefully
noted. On the lighted surface of the cylinder very little
gradation is shown on account of the brilliant illumination
and also the reflected light from the other objects. On the
prism, however, the hexagonal end shows the high light, the
top face shows the half light, the upper inclined right face
shows the half shade, and the lower inclined right face shows
the shade. The surface lighting of the hemisphere is, in this
position, similar to that of the sphere.

The shadow of the cylinder's long straight side would, of course, show parallel edges, if it could be seen unobstructed. The spherical end would cast a long, semielliptic contour on the horizontal supporting surface, but being interrupted by the vertical end of the prism it takes the form shown. The shadows of the prism and the hemisphere follow principles already discussed. The shadow cast by the upper part of the vase onto the lighted face of the pyramid forms an extremely interesting study.

For the present, there will be considered simply the light, shade, and shadow effects seen in Fig. 5. This is to be supplemented, however, by a careful study of the models arranged in the positions shown and conventionally lighted. This study will reveal many interesting shadow effects that are not revealed in a photograph.

LIGHT AND SHADE

DEFINITION OF TERMS

9. In model drawing, the term light, except when considering the source of illumination, refers to the effect on the object illuminated and not to the sun or a lamp. The **light** on an object is, therefore, the lightest or most brilliant part of the object; and, similarly, the **shade** is the darker part of an object; that is, it is the part not in the direct path of the illuminating rays. Care must be taken, however, to distinguish between shade and **shadow,** which is the image cast by an object onto some other body, or by a projecting part of an object onto the object itself.

At present, only the white-and-black values of light and shade will be studied. As every object has color, to portray objects naturally will require the use of colors in the drawing. But before any color work can be done satisfactorily, the contrasts of white-and-black values must be thoroughly understood; that is, the correct portrayal of the object makes it necessary for a person to know whether the part of the object

approaches pure white light or whether it approaches black, which is the absence of light.

10. The treatment of light, shade, and shadow in drawing direct from models and objects differs greatly from their treatment in architectural drawings. The architect is governed by certain geometric rules and principles and makes his so-called shadow tints according to accurately measured projections. As a result, he is able to show, in his elevation drawings, what parts project and what parts recede from the face plane of a building, even before the building is constructed. This kind of shadow projecting is, therefore, a mechanical process of accurately measured points, lines, and angles.

In contouring and portraying lights, shades, and shadows in pictorial and decorative work, there are no hard-and-fast rules for this work, neither are accurately scaled measurements used. The entire process is a freehand portrayal based on accurate laws. Nevertheless, there are certain principles governing the lighting, shade values, and shadow casting, which must be understood before the shadows of objects can be properly contoured.

———

LIGHTS

11. Direction of the Rays of Light.—As the lights on any object are those portions nearest the source of light and therefore most brilliantly illuminated, their size, luminosity, and general character depend, in large measure, on the direction and the angle of the illuminating rays. Although the illuminating rays diverge as they come from the sun, the sun is such an immense body of light, so many times larger than any object or group of objects on the earth, that, for all practical purposes, these rays may be considered as being parallel when they fall upon the object or objects. This parallel formation or direction is very clearly seen when the direct sunlight is allowed to shine through a small opening, or through several adjacent small openings in the window blind, into a dusty room not otherwise lighted. In Fig. 6, the little arrows x may be considered the beams or rays of light from

the sun falling onto the cube. They are marked "light rays"
and are parallel, as shown.

12. Angle of Light Rays in Conventional Lighting.
As shown in Fig. 6, in conventional lighting all light rays $x\,a$,
$x\,b$, $x\,c$, etc. are not only parallel but also fall upon the
object at an angle of 45°. In order to bring out the proper

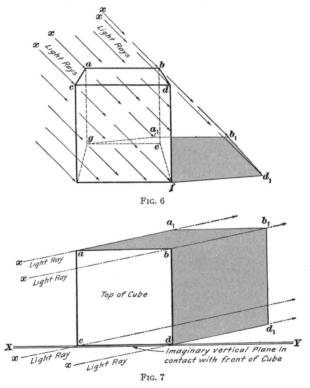

Fig. 6

Fig. 7

lighting and modeling of an object, a human face, a figure
with drapery, or a piece of decorative carving, the light is
not only assumed to be above and to the left of the object,
but slightly in front of the imaginary vertical plane that
touches the nearest part of the object. This is shown in Fig. 7,
where the light rays $x\,a_1$, $x\,b_1$, $x\,d_1$, which are the rays $x\,a_1$,
$x\,b_1$, $x\,d_1$ of Fig. 6 seen from above, come from a source in

front of the vertical plane, of which $X Y$ is the base line, and strike against the front of the cube. This may be proved by studying carefully the effects produced by conventional lighting on the wooden models when placed singly and in groups. Only conventional lighting will be used here in the study of lights, shades, and shadows.

13. High Light and Half Light. — The study of the models will show that the lightest part of the object, called

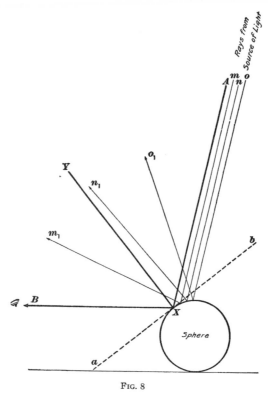

Fig. 8

the **high light**, is not always that part at right angles to the light rays. With the sphere, for example, the lightest part extends from the extreme upper part of the contour, where one would expect to find it, downwards. This apparent

spreading of the high light is due to the fact that the brightest spot is that from which the light rays are reflected from the object to the eye. It is well known that when a ray of light strikes a polished surface, such as a mirror, this ray is cast forwards to another point, say on a wall. The little experiment of catching a ray of light with a small mirror or other polished surface, and by changing the angle of the mirror making the "reflection" dance around over walls and ceiling is a very familiar one. It is also well known that the ray of light reflected from the mirror makes the same angle with the surface of the mirror as is made by the ray of light that falls upon the mirror.

This is shown in Fig. 8, where the light ray A coming from the source of light touches the surface of the sphere at X and is reflected to the eye B of the observer. The direct light ray AX makes the same angle with the curved contour of the sphere as is made by the reflected light ray XB. This is more clearly shown by drawing a dotted line $a\,b$, tangent to the sphere at the point X, and a line XY perpendicular to the line $a\,b$ at the point of tangency X. When the light ray AX comes from the source of light and falls onto the sphere at X it makes a certain angle, say 50°, with the perpendicular line XY. Experiment shows that when this light ray is reflected from the sphere and forms the reflected ray XB, the angle BXY is equal to angle AXY. There are multitudes of other light rays falling upon the sphere, but owing to the angles of reflection only a limited number are reflected direct to the observer's eye, and it is only the part of the sphere from which these are reflected that has the high light. In Fig. 8, light rays m, n, and o strike the sphere and are reflected to m_1, n_1, and o_1; as these reflected rays do not strike the eye, the part of the sphere from which they are reflected has not the high light, but may be considered as being in **half light.**

14. The high light may vary from a minute point of light to a broadly diffused brilliant surface, depending on the nature of the source of light (as the sun, an arc light, an incandescent lamp, a gas flame, etc.) and its brilliancy,

and the texture of the object receiving the light, whether polished, smooth, dull, or rough. In the case of the high light on the sphere, the dull surface caused by the grain of the wood makes a diffused high light. The wooden model of the sphere, brilliantly and conventionally lighted, should be looked at for a demonstration of this diffused high light. However, if this sphere were to be painted white or were to have a polished surface, such as that of a billiard ball, or if the entire surface were a mirror, the exact source of light would be reflected from this portion of the sphere, as, for instance, the shape (curved) of the window and window panes, from which the object is lighted. The high lights on other geometric solids will differ in brightness and form from that on the sphere.

SHADES

15. Half Shade.—A study of the sphere, when conventionally lighted, will show that the parallel light rays are interrupted when half way around the sphere; that is, at the widest part of the sphere. It will also show that, although the upper left-hand part of the sphere, which is facing the light, is quite bright and the lower right-hand part, which is turned from the light, is quite dark, the dividing line between the two is not sharply and distinctly marked. As the surface of the sphere is continually curving, the angles of reflection are continually changing so that the transition from high light to half tone and then to deepest shade is very gradual. Also, the light reflected from other portions of the room or surroundings, and even from the surface on which the object rests, has a great influence on this gradual transition from the light side to the dark side of the sphere. This partially light and partially dark value is known as the **half shade, half tone,** or **semitone.**

16. Deep Shade.—The darkest part of the side of the object turned away from the light is called the **deep shade** and is sometimes quite dark, although not usually as dark as the darkest part of the shadow. If the object is composed of flat planes and sharp edges, such as the cube, the pyramid,

etc., the transition from light to half tone or deep shade may be very abrupt, but if the object is cylindrical or spherical the transition will be very gradual. This can be observed by comparing the lights and shades on the cube, with those on the sphere.

17. Shadow.—Although frequently used interchangeably, the terms shade and shadow have not the same meaning. The shade is that part of an object that receives the least illumination; it is the darkest part of the object. The shadow is the effect produced upon some other surface when the object is between the surface and the source of illumination; in other words, it is the dark image cast upon a neighboring surface.

<div align="center">SHADOWS</div>

18. Formation of Shadows.—In Fig. 6, the light rays $x\,d_1$, $x\,b_1$, $x\,a_1$, etc. emanating from a source above, to the left, and slightly in front of the cube are intercepted by the cube

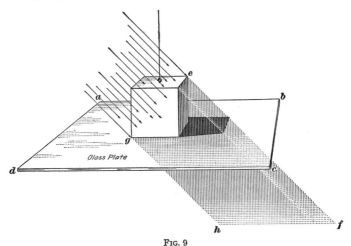

<div align="center">FIG. 9</div>

and therefore cut off. As a result a shadow $f\,d_1\,b_1$ is cast, or thrown, on to that part of the table or other supporting surface on which, if they were not intercepted, these rays would strike.

The reason for this is shown in Fig. 9. When the cube is suspended, the 45° parallel rays of light striking the cube are intercepted and *path of shadow e f h g* is formed. In this path all direct light rays are cut off and the illumination is much reduced; the path is of indefinite length and its sides are always parallel. Ordinarily, however, an object rests upon something; therefore, if a horizontal sheet of glass *a b c d* is held against the bottom of the cube, the path of shadow will go right through the transparent glass. However, if powdered chalk, salt, sand, or some similar substance is sprinkled upon the glass around the bottom of the cube, or if the glass is painted, the glass is made opaque. Then the shadow of the path is interrupted and caused to appear as shown by the very dark value on the glass to the right of the cube. It is of great importance that the art student should know the conformations of the shadows cast by various objects under different conditions.

19. Necessity for Accurate Plotting.—The first thought might be that there is no necessity for plotting shadows accurately when they are already there and need simply be drawn as they appear. That this idea is erroneous can be shown readily if one will attempt to draw cast shadows without knowing how they are actually cast. He will be sure to get the shadows out of place, their limits not definitely defined, and will make them appear simply as a sort of indefinable blur. A test will demonstrate this. Just as one must know, in a general way, the anatomy of the human figure in order to draw properly a man standing, or walking, or in some other posture or action, so he must really know the anatomy of the shadow before he can correctly draw the shadow itself. An inspection of the work of the best artists and illustrators will reveal the evidences of an exact knowledge of shadow casting.

20. Basic Principles of Shadow Casting.—The proper delineation of a shadow depends on two general principles, which—if properly understood and applied—will enable one to draw properly the cast shadow of any object. These are:

The shadow is regular in shape when viewed from above. This regular shadow must be foreshortened when viewed from in front.

The light rays, coming from the left and above at an angle of 45° (or at some other angle) are parallel when seen from the front, and combine with the plan of these same light rays, when seen from above, as they strike the front of the object at a slight angle, thus forming a regular symmetrical shadow.

This regular shadow, as viewed from above, will appear foreshortened when viewed from the front, and must therefore be drawn according to the principles of foreshortening so as to appear in its proper shape when viewed from the front.

The first principle was clearly demonstrated in Fig. 6, where the rays are seen coming down at 45° and parallel, and also in Fig. 7, where the rays are also parallel but fall upon the face of the object at a slight angle. This is also shown in Fig. 10 (a), where a light ray comes down at 45° and after passing through d, marks off a distance x y as the length of the shadow, extending out from right side of the cube. In view (b), this shadow is shown in its true formation at a a_1 b_1 d_1 d b. It must be remembered that as the light comes at an angle against the front face of the cube the rear face a b also casts a shadow, as shown, thus giving the peculiar pointed conformation to the whole shadow. In view (c), the lines of views (a) and (b) are combined, thus showing the cube and its shadow foreshortened according to principles that have already been given.

21. A Shadow Cast onto a Horizontal Surface. When drawing from the object it will not be necessary to lay out an elevation and a plan as shown in Fig. 10 (a) and (b). To simplify the process, the general direction of the ray of light foreshortened, that is, the general direction of the front edge of the actual shadow as seen, may first be sketched in at the angle it appears and as a line of indefinite extent, as at f d_1 x, Fig. 10 (c). The light rays e b_1 x and g a_1 x are also sketched in, following the same general direction as f d_1 x but with a slight convergence, so that, if continued, they will eventually

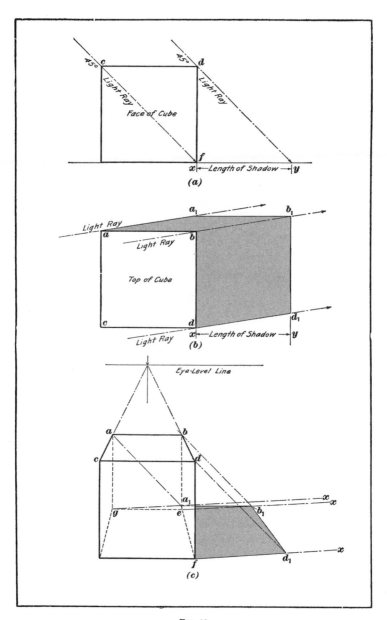

FIG. 10

meet at a point on the eye-level line, thus foreshortening these rays. It simply remains, therefore, to draw lines downwards at 45° through the corners a, b, d that cast shadows and where these 45° lines cut the converging rays $f\,d_1\,x$, $e\,b_1\,x$, and $g\,a_1\,x$, will determine the limits of the shadow.

Note that when the 45° line is drawn through a certain point it must stop at the horizontal converging ray that goes through the point directly under the corner through which the 45° light ray passes. Thus the 45° line through corner d must stop on light ray $f\,d_1\,x$ (at d_1); the 45° line through corner b must stop on light ray $e\,b_1\,x$ (at b_1); and the 45° line through corner a must stop on light ray $g\,a_1\,x$ (at a_1).

Of course, the shadow will start at the nearest edge f that casts a shadow, and will end at the farthest edge g that casts a shadow. This will make the contour of the shadow $f\,d_1\,b_1\,a_1\,g\,e$; only that part to the right of edge $d\,f$ will be seen from the front, however.

22. While by this time lines may be drawn, by eye measurement, at any desired angle with a reasonable degree of accuracy, in some cases absolute accuracy is required. An accurate 45° angle may be obtained by drawing upon a square piece of cardboard, a diagonal from the upper left-hand to the lower right-hand corner, and cutting the cardboard on this diagonal. Either of these pieces will then serve as a convenient means of drawing 45° lines. The lower edge should be moved along the base line until the oblique edge touches the point through which it is desired to draw the 45° line, and this line is then drawn until it is stopped by the light-ray line extending outwards and slightly backwards to the right, as previously described.

23. A Shadow Cast Also Onto a Vertical Plane. Frequently, an object is so placed that its shadow falls not only on the horizontal supporting plane but also upon a neighboring vertical plane or other object. In casting the shadow upon such a neighboring plane or object, the same principles are followed as in the case of the horizontal plane, except that the horizontal light rays, as soon as they touch the vertical plane,

are diverged from their path and go up along the face of the
vertical plane, and thus become vertical lines. This is shown
in Fig. 11, where the shadow of the cube is cast partly onto
the horizontal supporting surface and partly onto the vertical
plane $m\,n\,o\,p$.

To plot this shadow, the cube $a\,b\,d\,c\,g\,e\,f$, and the vertical
plane $m\,n\,o\,p$ are drawn in their proper foreshortened posi-
tions, the vertical plane being parallel to the right-hand face
of the cube; that is, edges $p\,o$ and $m\,n$ of the vertical plane
will converge at the same point in the eye-level line as the
edges $b\,d$ and $e\,f$ of the cube. Next, the horizontal light
rays $f\,d_1\,x$, $e\,b_1\,x$, and $g\,a_1\,x$ are drawn, slightly converging, as

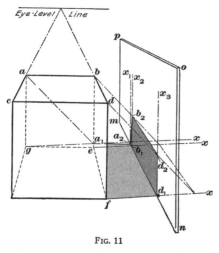

FIG. 11

before. As these rays
are interrupted at d_1, b_1,
and a_2, by the bottom
edge $m\,n$ of the vertical
plane, they must be de-
flected upwards and fol-
low the surface of the
vertical plane; they
therefore no longer con-
verge but become verti-
cal lines $d_1\,x_3$, $b_1\,x_2$, and x_1.
It simply remains to
draw 45° lines through
points a, b, and d until
they cut light rays $g\,a_1\,x_1$,
$e\,b_1\,x_2$, and $f\,d_1\,x_3$ and
thus locate point a_1 on the horizontal plane, points b_2 and d_2,
as the limits of the vertical shadow. Point a_2 is found by
drawing a line from b_2 to the point where the horizontal part
of the original shadow touches the base $m\,n$ of the vertical
plane $m\,n\,o\,p$. The contour of the shadow, partly on the hori-
zontal plane and partly on the vertical plane, is thus com-
pleted, as shown at $f\,d_1\,d_2\,b_2\,a_2\,a_1\,g\,e$, in Fig. 11.

24. **A Shadow Cast onto Neighboring Planes or
Objects Not Vertical.** — The neighboring plane may not

always be vertical, but may slant toward or away from the
cube, as in the case of a pyramid or a hexagonal prism lying
on its side. In such cases the same principles are followed
as before, the horizontal light rays being deflected upwards
to follow the face (foreshortened) of the plane receiving
the shadow; but the shadow lines of the vertical edges of the
cube will not follow, and be parallel with, the ends of the
inclined plane. Experiments should be made of placing a
cube so that it casts a shadow on a vertical plane (as a piece
of cardboard or an envelope held vertically) as in Fig. 11.

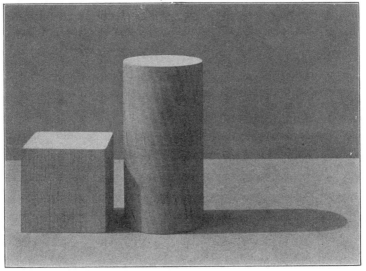

Fig. 12

Keeping the bottom of the plane *m n* in contact with the
horizontal supporting surface and not shifting it at all, the
top edge *p o* should be swung downwards and away from the
cube, so that front edge *n o* makes an angle of 60° or 45°.
It will then be noticed that the shadow edge $d_1 d_2$ does not
remain parallel to edge *n o* but inclines backwards and away
from it and the upper edge of the shadow $b_2 d_2$ remains parallel
(foreshortened) with the lower edge of the plane *m n*, as
before.

If the vertical plane is inclined toward the cube instead of away from it, the upper corner d_2 of the shadow comes forwards toward the edge $n\ o$, instead of retreating from it.

An application of these principles of shadows cast onto inclined planes will be made on the regular plates in this Section. It will not be necessary to plot out such shadows according to definite measurements, if the principles learned so far are applied when doing the freehand sketching of the shadows that are actually seen.

25. A Shadow Cast onto a Curved Surface.—When the shadow is cast onto a curved surface, the first noticeable effect is that the shadow contour consists of curved lines. The

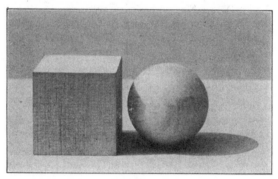

FIG. 13

plotting of this shadow is governed by the general principles of shadow casting, so that a careful study of the various forms of shadows cast by objects of different contours upon curved surfaces will enable any one, knowing these principles, to draw such shadows accurately.

In Fig. 12 is shown the contour of a shadow cast, by a cube, upon a cylinder, where only the horizontal edges of the cube cast a curved shadow. The vertical edges cast a vertical shadow because the cylinder is not curved in a vertical direction; only in a horizontal direction.

However, in the case of the shadow cast by the cube upon the sphere, Fig. 13, the lines forming the contour of the shadow

are all curved because the receiving surface, that is, the surface of the sphere, is itself curved in all directions.

26. The Shadow of an Object Having Curved Contours.—When the object that casts the shadow is cylindrical or spherical in form, the contours of the shadows of the curved portions must be curved, whether the receiving surface is flat or curved. The graphic plotting of these shadows will be described in connection with the description of the cylinder, sphere, hemisphere, and vase, and therefore need not be given here.

DEMONSTRATIONS WITH THE WOODEN MODELS

INTRODUCTION

27. To understand clearly the effects of light, shade, and shadows, the wooden models should be carefully studied when conventionally lighted. But to secure the best results from this study one of the following plans should be adopted:

1. If the demonstrations with the models are made during the spring or summer, place the model upon a table that has been put outdoors where the sun's rays can strike it, as in an open yard, upon a flat roof, on a veranda, etc. Then, between 9:30 and 11:30 A. M. and between 1:30 and 3 P. M. the shadows cast by the sun will be sufficiently satisfactory to give conventional lighting even though the rays may not be at an angle of exactly 45°.

2. If the work is done in some other season, or if conditions are such that these demonstrations cannot be made out of doors, the models may be placed on a table, with a window to the left of it through which the direct rays of the sun shine in upon the model at a 45° angle. The demonstrations must be made, as before, between 9:30 and 11:30 A. M. (preferably at 10 o'clock) and 1:30 and 3 P. M. (preferably at 2 o'clock). Depending on the season or the geographical location, these hours may have to be altered. In all cases good judgment must be used in selecting the proper times for these demonstrations.

3. If direct sunlight is not available, a good north light coming from a window at the left of the table upon which the object is placed will give fairly sharp shadows.

4. If it is necessary to work by artificial light, the model can be illuminated in such a manner by an electric bulb, an inverted gas light, an ordinary portable gas reading lamp, or even an oil lamp, as to give sharp shadows. Of course the light rays from such artificial light will not be perfectly parallel, as in the case of sunlight rays, but the shadows will be sufficiently sharp to study.

The models should be studied under at least one of these conditions so that the effects produced may be fully understood. In all cases, though, an effort should be made to secure a brilliant concentrated light as the source of illumination. The models should be placed about 2 feet from the eye and from 10 to 12 inches below it. A piece of light gray cardboard should be set up vertically, back of the models, but not so as to obstruct the light, and also beneath them. This is the manner in which the models were arranged when they were photographed for Figs. 1 to 5, and 12 to 32.

THE CUBE

28. Demonstration With the Cube Full Face.—The cube should now be placed in such a position that the model and its shadow will ap-

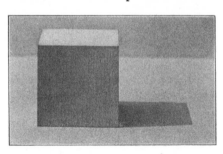

Fig. 14

pear about as in Fig. 14. This illustration is given simply as an aid in arranging the cube properly and the lighting should be so arranged that the lights, shades, and shadows of the wooden model are about as shown in the illustration. After that, no further reference should be made to the illustration, but all demonstrations should be made with the wooden model itself, and all observations made from it.

Only the front and the top of the cube are visible and neither of these are very brilliantly lighted because the direct rays of light are reflected beyond the eye to the right. The top appears brightest because it is at the proper angle in relation to the light rays and to the line of sight; that is, it is parallel with the supporting surface. The end grain of the wood also increases its brightness. The top, therefore, may thus be considered the high light. The front face is slightly duller than the top, although not directly in shade, because it receives an oblique light. In fact, no distinct dark shade is evident in this full-face view of the cube; one would have to move toward the right and look at its right side to discover the shade.

29. The shadow of the cube full face, in conventional lighting, is a simple one, and the method of plotting was given when the graphic diagrams of the plotting of this shadow, given in Fig. 10, were described. The shadow cast by the model should be carefully studied to see how nearly it conforms to the principles of plotting the location, the direction, and the extent, that have already been given. If the light rays do not make an angle of exactly 45°, the shadow may be longer or shorter but the principles of plotting the shadow will remain the same.

30. Demonstration With the Cube at an Angle. The cube should now be placed with one vertical edge toward the observer, that is, cornerwise, as shown in Fig. 15, the conventional lighting being arranged as previously described.

In this position, three faces of the cube are visible, and the three gradations of lighting, high light, half shade, and deep shade, are now

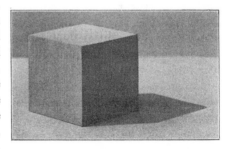

Fig. 15

evident. The top of the cube is most brilliantly lighted, and is the high light, not only because it is nearest to the direct rays,

but because the angle at which the light rays strike it is such as
to throw them direct to the eye. The left side is not quite so
brilliant, because it is sharply inclined away from the eye, thus
shedding the reflecting rays, and is the half shade. The char-
acter of the grain of the wood has some influence on these
relative lights.

The right side receives no direct rays at all, because it is
turned away from the source of light and is the darkest part
of the object, and is therefore called the shade. The only
reason the shade side of the object is not totally dark is because
it receives reflected light from other objects or surfaces in
the room. The shadow appears as dark as it does because
it is in such a position (horizontal) that it does not receive
much of this reflected light, although in this instance it receives
some. It will be noticed that the shade side of the cube
varies in its degree of shade, being darkest near the bottom,
that is, nearer the shadow.

31. It will be seen at once that the shadow cast by the
cornerwise cube is of quite a different shape from that cast
by the full-face cube. The method of plotting this shadow,
however, is exactly the same as that used in the case of the
full-face cube. In Fig. 16 (a) is shown a front elevation of
the cube, both the left and the right sides showing, with the
light rays coming down through d and b at a 45° angle and
marking off at d_1 and b_1 the limits of the length of the shadow.
In (b) is shown the true formation of this shadow when viewed
from above, and which must be foreshortened just as the cube
that casts it is foreshortened. In (c) is shown the foreshortened
cube and its shadow.

The practical method of getting this shadow is, as before,
first to sketch in the horizontal light rays $g\ a_1\ x$, $e\ b_1\ x$, and $f\ d_1\ x$,
directly under points a, b, and d, respectively. The 45° light
rays are then drawn through a, b, and d. Where the one
through a cuts ray $g\ a_1\ x$ marks a_1; where the one through b
cuts ray $e\ b_1\ x$ marks b_1; and where the one through d cuts $f\ d_1\ x$
marks d_1. By connecting g, a_1, b_1, d_1, f, e, and g, the contour
of the shadow is defined. Section $g\ e$ remains hidden.

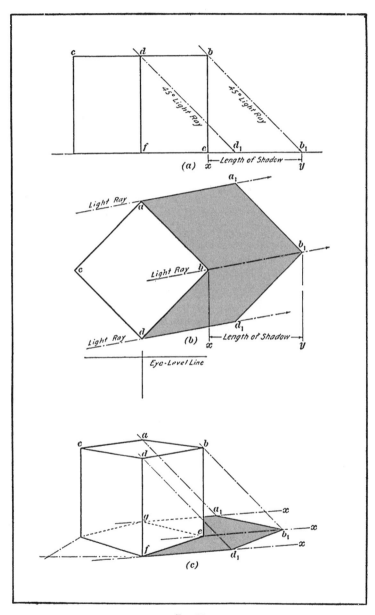

FIG. 16

THE PYRAMID

32. Demonstration With the Pyramid Full Face.
Place the square pyramid in conventional lighting, with one
face toward the observer, as shown in Fig. 17. For these
various demonstrations with the models the same arrangement
of lighting must be maintained, the models must always be
placed at the same position or spot on the table (it would

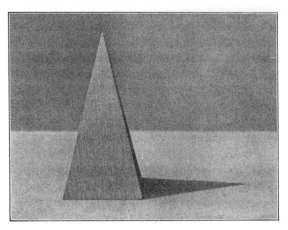

FIG. 17

be well to mark it with pencil or chalk), and the observer
should always sit at the same relative position in front of
the model.

The front face of the pyramid will be bright, although
the small portion of the left side, if visible, may be equally
bright, depending on the angle of light. The right side is
in shade, being turned entirely away from the source of light.
The tone value of this shade and of the shadow and their
variations follow the same principles as were described for
the cube seen full face.

**33. Shadow of Pyramid Cast onto a Horizontal
Plane.**—It will be observed at once that a pyramid casts a
shadow with two long sides meeting in a point. The method
of plotting it, however, is the same as was used in the case of

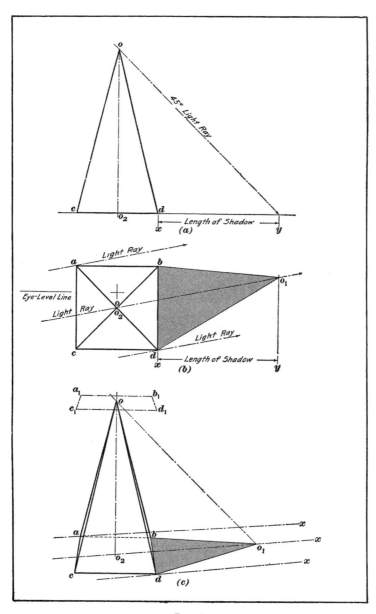

FIG. 18

the cube; this is shown in Fig. 18, where (*a*) is a front elevation of the pyramid full face, which is a triangle. The 45° light ray marks off *x y* as the complete limit of the length of the shadow. The true formation of the shadow is shown in (*b*). It must be remembered that the shadow is cast by the edges running up to the apex *o*, which apex is exactly above the center of the base, as is shown in (*c*) by apex *o* at the center of foreshortened rectangle $a_1 b_1 d_1 c_1$ directly above base *a b d c*.

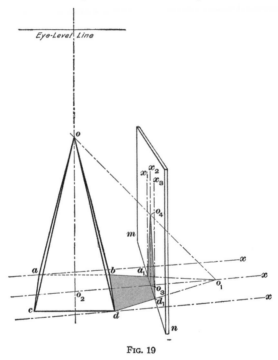

FIG. 19

Therefore, the horizontal light rays must be drawn through base corners *a* and *d*, and through center *o*. In (*c*) is shown how the 45° light ray cuts the horizontal light ray $o_2 x$ at o_1, this point then being connected with *b* and *d*, thus completing the shadow *b o_1 d*.

34. Shadow of Pyramid Cast onto a Vertical Plane. The method of plotting the shadow that falls partly onto a

horizontal and partly onto a vertical plane has been described in connection with the shadow cast by a cube. Fig. 19 shows that the same principle of plotting applies to the shadow of the pyramid. When the horizontal shadow lines meet the bottom of the vertical plane $m\,n$, that is, at a_1 and d_1, they are deflected upwards. The shadow of the apex will fall upon a vertical line drawn upwards from o_3, and at a point on this line where the 45° ray cuts it, namely point o_4. This point o_4 is connected with points a_1 and d_1, thus forming the contour of the part of the shadow that falls on the vertical plane.

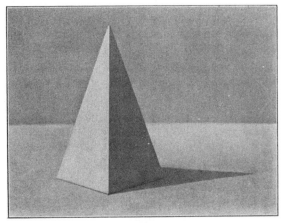

FIG. 20

The same general principles apply when the shadow falls onto inclined planes, curved surfaces, etc., of neighboring objects. It is therefore not necessary to give directions and diagrams for plotting such shadows. Knowing the principles of casting the shadow of the pyramid onto the horizontal and the vertical planes, one can draw, with sufficient accuracy, shadows on inclined and curved surfaces, as they appear to him.

35. Demonstration With the Pyramid at an Angle. Using the same lighting as before and keeping the same position from which to view the model, turn the pyramid around so that one corner of the base is nearest the observer, as in Fig. 20. Now two faces are visible. The left one is in full light and

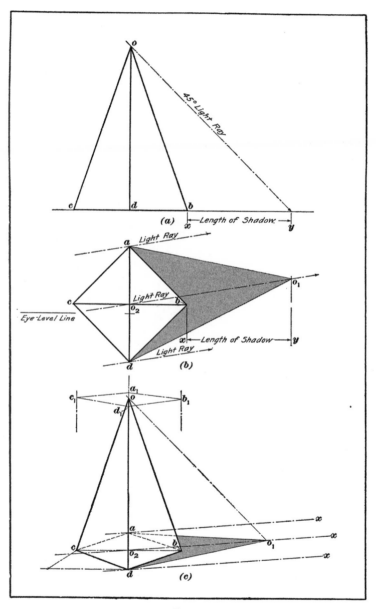

FIG. 21

quite bright because it reflects the light rays directly to the eye, and the right is one in shade because it is turned away from the source of light. There is thus high light and shade only; there is no half shade. The shade side and the shadow vary in depth of tone, as before explained. It should be observed that the shade sides of objects are deepest in tone value at the near edge, thus contrasting with the light side, and gradually appear less dark as they recede from the eye.

36. The plotting of the shadow for the pyramid seen at an angle contains no new principle, the same method being employed as was used in the case of previous models. The diagram showing this method is given in Fig. 21 (a), (b), and (c), and needs no description. Care must always be taken to run the horizontal light ray, upon which the shadow of the apex is to be located, through the central point o of the base, found by means of diagonals, for the apex is always directly above this central point of the base. The shadow of the cornerwise pyramid can be plotted also on vertical and inclined planes, and on curved surfaces, as previously explained.

THE HEXAGONAL PRISM

37. Demonstration With the Prism Vertical.—The hexagonal prism standing on end, should now be viewed with one flat face toward the observer, as shown in Fig. 22. Three sides and the top are visible. This is an excellent example of high light, half shade, and shade, all on the same object. The top, that is, the upper end, is the high light because it is turned toward the source of light and reflects the light rays to the eye. The left visible side is well lighted but not so brilliant as the top, and may be considered as half light. The front face is obliquely lighted and is the half shade. The right visible side is turned away from the source of light, and is in shade; this shade and the shadow vary in evenness of tone value, as before described.

These graded values, distinctly marked by the edges of the prism faces and showing high light, half light, half shade

and shade, will serve as an introduction to the more subtle
gradations of high light, half light, half shade, and shade to
be observed later on the curved surfaces of the cylinder, cone,
sphere, hemisphere, and vase.

38. Just as the foreshortening of the hexagonal prism
is done on the principles used in the foreshortening of the
cube full face and the cube at an angle, so the shadow of
the hexagonal prism is plotted by using a combination of the
methods used for the plotting of shadows cast by the full-face

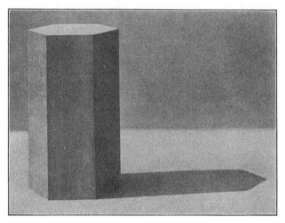

Fig. 22

cube and those cast by the cube at an angle. Fig. 23 (*a*)
shows the 45° light rays locating the extent of the length of
the shadow; view (*b*) shows the actual shape, $a\,a_1\,b_1\,c_1\,d_1\,d\,c\,b$,
of the shadow when seen from above, in which it is observed
that horizontal edges cast shadow edges parallel to themselves;
as $a_1\,b_1$ parallel to $a\,b$; $b_1\,c_1$ parallel to $b\,c$; and $c_1\,d_1$ parallel
to $c\,d$. View (*c*) shows the practical method of foreshortening
the shadow directly, without plan and elevation drawings.

The method of plotting the shadow of the prism on a ver-
tical plane and also on inclined planes and curved surfaces is
the same as has been described for the plotting of shadows
of the cube and the pyramid on similar surfaces.

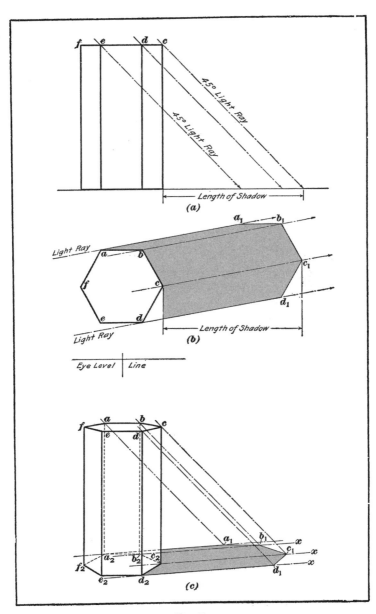

FIG. 23

39. **Demonstration With the Prism on Its Side.**
The light-and-shade effects of the prism lying on one side
can be observed by placing the model in such a position, so
that one end, foreshortened, and three long faces, very much
foreshortened, are seen. The long face at the top and the
one on the left adjacent to it, although not seen by the observer,
will receive the brightest light; the right upper and the left
lower faces will be in half shade and the right lower face will
be in shade. This is shown in the case of the horizontal prism
in Fig. 5.

The shadow will be simple in shape; therefore, no diagram
for plotting need be given. It will appear similar in shape
to the shadow of the cube at an angle, with the lower right-
hand corner of the shadow cut off. A demonstration with
the prism in this position should be made.

THE CYLINDER

40. When the cylinder is standing on end, as shown in
Fig. 24, the circular top is lighted about the same as the tops of

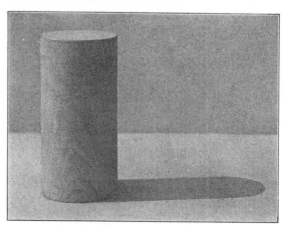

FIG. 24

the cube and hexagonal prism. But the lighting on the rest of
the surface of the cylinder is quite different from any heretofore
observed. So far only flat planes of light have been shown,

each with a definite extent and sharp limiting edges. The curving surface of the cylinder, however, shows light and shade values blending into each other.

The high light is a vertical band of light a short distance in from the left-hand contour of the cylinder. The position of the high light is determined by the angle at which the rays of light strike the cylinder and are reflected to the eye; only a few planes of rays are thus reflected. This was fully shown in Fig. 8, and explained in the accompanying text, to which the student should again refer. This high light would be extremely brilliant if the surface of the cylinder were made of some polished metal, or even if this wooden cylinder were painted white and varnished, or were enameled with white enamel paint. This can be demonstrated by using any cylindrical tin, nickel, or silver object, such as a tin can, some cylindrical kitchen utensil, or the nickel-plated container in which sticks of shaving soap are put up.

41. The high light on the wooden cylinder shows a gentle gradation into a half light or half shade at the left contour of the cylinder, and a similar gentle gradation toward the right. As the high light diminishes as it goes toward the right, the half light comes about opposite the eye of the observer, that is, on the nearest part of the cylinder, the half shade is a little to the right of that, and between the half shade and the extreme right-hand contour of the cylinder is the shade. On a polished cylinder, however, the shade does not extend up to the extreme right-hand edge, for along this edge there is a narrow band of light. This is caused by reflected light rays and other causes it is not necessary to specify here. This band of half light bordering on the shade at the extreme edge of the cylinder may not be so observable in Fig. 24, but on a polished cylinder it is always visible, and must be looked for and portrayed when a polished cylindrical object is being delineated.

The shadow, as before, is darker in tone value than the shade on the object, unless strongly affected by reflected light and it is darkest near the base of the cylinder.

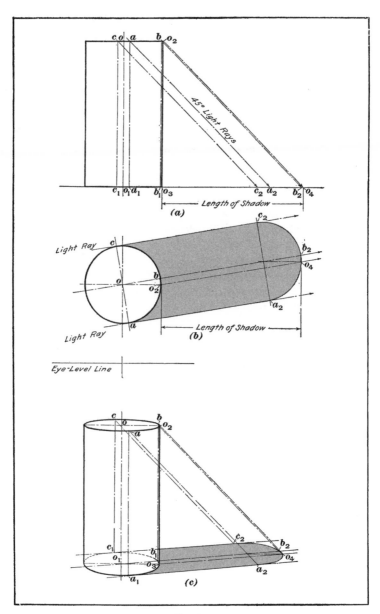

Fig. 25

42. As seen in Fig. 25 (a), (b), and (c), the principles of plotting the shadow of the cylinder are the same as used for plotting the shadows of the other models, but care must be taken to pass the 45° light rays through the proper points and the horizontal light rays through the corresponding points directly underneath them. View (b) shows that the slight angle at which the horizontal light rays strike the cylinder makes them tangent thereto, that is, makes them touch the cylinder, at points a and c; the lines showing the light rays must be drawn through those points.

Point o_2 in all views is the greatest extension of the right side contour of the cylinder, and in (c) point b_1 is the point where the horizontal light ray through center o_1 cuts the circumference. Lines for the horizontal light rays must be drawn through these points. In view (a), these points c, a, b, and o_2 are shown at their relative positions when viewed from the front and the 45° light rays are then drawn through these points to cut the corresponding horizontal light rays, thus locating points c_2, a_2, b_2, and o_4. When these points, in views (b) and (c) are connected by curves, and the straight lines $c_2\,c_1$ and $a_2\,a_1$ are drawn, the contour of the shadow is completed as shown. Part of the shadow will of course be hidden by the body of the cylinder, as shown in (c).

Frequently the cylinder is shown lying on its side, making an angle with the eye of the observer. The principles under which such a foreshortened view of the horizontal cylinder is drawn have already been presented in an earlier Section. The shadow projected by the cylinder in this position is plotted in the usual way, by passing 45° light rays through established points on each end of the cylinder so as to cut the horizontal light rays at the proper points, these points then being connected so as to make the contour of the shadow. This shadow contour, as well as the light and shade values, in one position, is shown in the case of the horizontal cylinder in the group in Fig. 5. Experiments and demonstrations with the wooden model of the cylinder will reveal other shadow formations, not only on a horizontal surface, but also on vertical surfaces, inclined surfaces, curved surfaces, etc.

THE CONE

43. The study of the cone, Fig. 26, will show that the same effects of high light, half light, half shade, and shade will appear on the cone as were observed on the cylinder. As the surface of the cone is not vertical, but converges upwards toward the apex, the high light, half shade, shade, etc., will appear not as parallel bands, but as very pointed triangles. There will also be a tendency for the cone to be somewhat

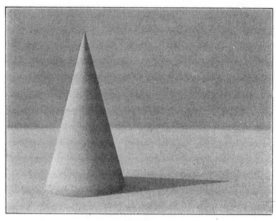

Fig. 26

brighter toward the apex than at the base, depending, of course, on the exact angles of the rays of light.

The plotting of the shadow of the cone is a simple matter, as can be seen from Fig. 27 (a), (b), and (c). The apex casts its shadow at 45° onto the horizontal ray $o_2 x$, view (c), running through the center of the base, thus establishing point o_1. Through point o_1 are then drawn lines tangent to the foreshortened base of the cone at a and b, thus forming the shadow $a\, o_1\, b$, part of which is hidden by the body of the cone.

The shadow of the cone on vertical and inclined planes and on curved surfaces is plotted as was the shadow of the pyramid on similar surfaces.

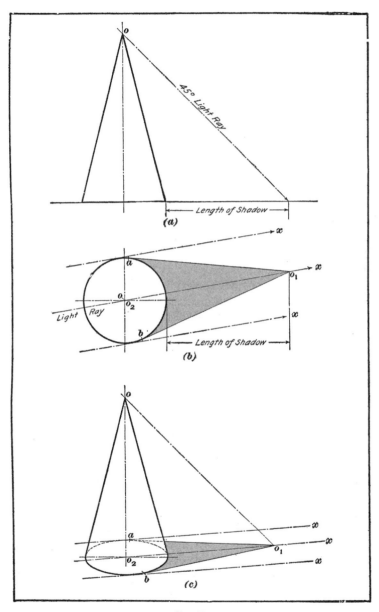

FIG. 27

THE SPHERE

44. Demonstration With the Sphere.—Any one who has carefully made all the demonstrations with the various models so far described, and has observed the effects of light,

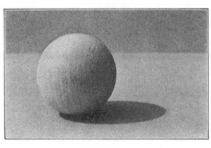

FIG. 28

shade, and shadow that occur in the case of objects that have flat sides and sides curved in one direction, will have no difficulty in the study of the sphere. The appearance of this model conventionally lighted is shown in Fig. 28. A small piece of wax or soap placed beneath the sphere will keep it steady while it is being studied.

The lights, shades, and shadow of the sphere in conventional lighting should be studied long and carefully, for this spherical shape is the underlying base of many objects that will be drawn later.

45. As the surface of the sphere is continually curving convexly in all directions, there are no planes and therefore no abrupt divisions of light and shade because the rays of light falling on this curved surface are reflected at all possible angles from this surface. As previously described, only a few light rays strike the curved surface of the sphere in such a way as to make a really bright spot of high light on the upper left-hand section of the visible surface of the sphere. From this spot of high light the values gradually deepen to half light, then to half shade, and finally to shade on the lower right-hand section of the sphere. The sphere rests, theoretically, on a point and therefore the half shade and the shade are observed not only on the right side of the sphere but also partly on the under side. The shadow cast by the sphere falls not only to the right, but actually under the sphere.

46. It has already been shown that, to draw the sphere, one need make no attempt to foreshorten it but should simply draw a circle, depending on the rendering later to portray the effect of roundness and solidity. Likewise, in drawing the shadow of the sphere one need not plot the shadow according to definite principles, but need simply draw it as he sees it when cast by the actual model, and as illustrated in Fig. 28.

47. When necessary, however, the shadow cast by a sphere may be plotted graphically in the same manner as shown in the constructive diagrams, Fig. 29. The sphere may be considered as a large transparent ball upon which a series of opaque black rings may be painted. These rings may be represented in the elevation (a) as straight lines $a\,b$, $c\,d$, $e\,f$, $g\,h$, and $i\,j$; and in the foreshortened view (c) as ellipses. The 45° light ray that passes through the point b, in view (a), strikes the horizontal supporting surface at b_1; another 45° light ray passes through point a and strikes the horizontal supporting surface at a_1, thus forming the extent, or length, of the shadow of the painted ring $a\,b$ in view (a). This is clearly shown in view (c), where the projected shadow of ring $a\,b$ is shown by ellipse $a_1\,b_1$. The shadow is of course centered on the central horizontal light ray $x\,x_4$. In a similar manner the shadows of the other painted rings are projected; ring $c\,d$, view (c), gives shadow $c_1\,d_1$; ring $e\,f$ gives shadow $e_1\,f_1$; ring $g\,h$ gives shadow $g_1\,h_1$; and ring $i\,j$ gives shadow $i_1\,j_1$. The actual shapes and positions of these shadows when seen in plan, are shown in view (b), where the five overlapping circles are shown, but to prevent confusion are not lettered.

48. It is understood, of course, that the depth of these shadows, the lengths of which have already been obtained, are influenced by the positions of their appropriate horizontal light rays. View (b) shows that the depth of the largest ring $e\,f$, view (a), is determined by the parallel light rays passing through e_2 and f_2, namely light rays $x\,x_1$ and $x\,x_7$, thus giving the actual depth of the shadow in plan as $e_3\,f_3$, view (b); and its actual depth foreshortened as $e_3\,f_3$ in view (c). In a

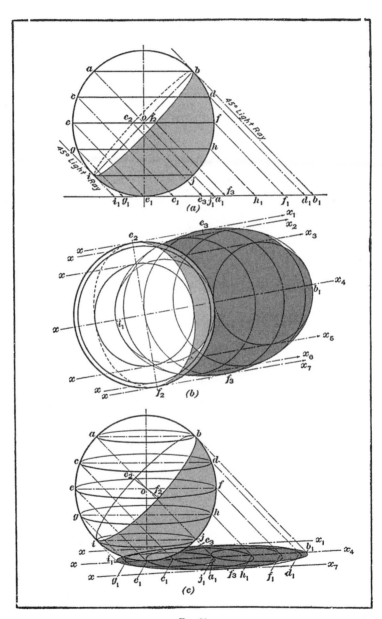

FIG. 29

similar way the depths of the shadows of the other rings are obtained.

There are now formed five circular shadows placed as shown in (b) of Fig. 29, and five elliptic shadows as shown at (c) of Fig. 29. As shown, these shadows will overlap, and it therefore simply remains to enclose them all in one large elliptic shape [foreshortened in (c) of Fig. 29], i_1, e_3, b_1, f_3, and to shade it in as shown, which will represent the shadow of the sphere. As before, a portion of this shadow will be hidden by the body of the sphere itself.

49. Simple Method of Plotting Shadow of a Sphere. While the principles of plotting the shadow of a sphere should be understood, the following working plan may be used: As the light rays fall parallel and at 45°, the points of tangency made by them on the sphere form what may be termed the *great circle*, which is shown as the oblique ellipse $i\ e_2\ b\ f_2$, view (c). This circle is inclined at a 45° angle with the ground because it is at right angles to the 45° light rays falling on the sphere. The upper end b of the great circle casts shadow point b_1 and the lower end i casts shadow point i_1, thus determining the length of the shadow. The depth of the shadow is determined, as before, by the limits of the parallel horizontal light rays. The large ellipse to portray the shadow may then be sketched in freehand without further difficulty.

When sketching direct from the sphere, these diagrams need not be employed literally, but they should be kept in mind while working. The working plan should be to draw two 45° tangent lines, the right-hand one touching the upper right-hand curve of the sphere's contour, and the left-hand one touching the lower left-hand curve of the sphere's contour, thus locating on the horizontal supporting surface the extreme right end and the extreme left end, respectively, of the shadow. The depth of the shadow may be judged by eye measurement and then the shadow be drawn freehand as an ellipse.

50. When the shadow of the sphere falls upon a vertical plane, the horizontal light rays used as guides for the depth of the shadow cast horizontally are deflected upwards along

the vertical surface and thus become vertical lines. These vertical lines are then cut by the 45° light rays passing through certain selected points on the inclined great circle, thus determining points to contour the foreshortened curve of the shadow. The same principle is used for the casting of the sphere's shadow upon inclined planes and curved surfaces, but in these cases the directions of the ascending lines of light rays must be plotted as they appear.

FIG. 30

THE HEMISPHERE

51. The model of the hemisphere should be so arranged that the flat portion is up, and is perfectly horizontal. This can be accomplished by sticking a small piece of wax, or soap, onto the rounded portion of the hemisphere upon which it rests, and then pressing the hemisphere down until it touches the table or other object upon which it rests, keeping the flat part absolutely level and horizontal, as is shown in Fig. 30.

The circular flat portion of the hemisphere will be lighted exactly as was the circular top of the cylinder; and the curved surface of the hemisphere will be lighted about like the lower half of the sphere.

The plotting of the shadow is also a simple matter for one who has plotted

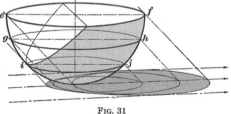

FIG. 31

the shadow of the sphere. As shown in Fig. 31, it is only necessary to cast, on the supporting surface, the overlapping shadows of ellipses *e f*, *g h*, and *i j*. These elliptic shadows are then extended and rounded off so as to make one large ovate

ellipse, or oval, which is the shadow of the hemisphere. In other respects the casting of the shadow of the hemisphere onto horizontal, vertical, and inclined surfaces, and onto curved surfaces, is done as in the case of the shadow of the sphere.

THE VASE

52. Although the vase is apparently very simple in its curves and contours, yet a study of it when placed in conventional lighting, as in Fig. 32, will reveal combinations of effects seen singly on the cylinder and the sphere, as well as many other points about light, shade, and shadow that will be of great interest.

The top of the vase is in a sort of very bright half shade, just as were the tops of the cylinder and the hemisphere.

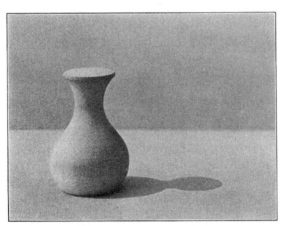

FIG. 32

The brightest part, the high light, is about midway between the top and bottom of the vase and near the left contour. The widest part of the vase is in reality spherical and the high light falls as it does onto the sphere. Blending with this high light is the one on the neck, which is similar to the high light on a cylinder. The half lights, half shades, lines of reflected light at the right contour, etc. are located as has been described already for the sphere and the cylinder. A

careful study of the model will reveal many other details, ' to which it is not necessary to call attention at this time.

53. As in the case of the sphere, it will not usually be necessary to plot accurately the shadow cast by the vase. An accurate plot, however, may be made when required by casting the shadows of circles, or disks, centered on the central horizontal light ray, and then combining and overlapping these shadows so as to make a complete shadow, as shown

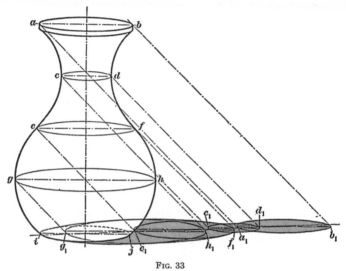

FIG. 33

in Fig. 33. First the shadow of the top $a\,b$ should be cast upon its appropriate horizontal light rays, when it will appear as the elliptic shadow $a_1\,b_1$. Next, the shadow of the narrowest part of the neck $c\,d$ should be cast; this will appear as the small elliptic shadow $c_1\,d_1$. The casting of the shadows of circles representing the spherical portion of the vase $e\,f$, $g\,h$, and $i\,j$ is simply a duplication of what has been done in the case of the sphere; these make shadow $i\,f_1$. These separate elliptic shadows are then combined by softening off and joining the curves, thus making the complete shadow as shown.

The principles of plotting shadows of cylindrical and spherical objects onto various planes have already been explained.

MATERIALS AND METHODS OF WORK

PRELIMINARY PRACTICE

54. Portraying Tone Values.—In the portraying of tone values, broad tints and tones are placed upon the paper by means of charcoal, which is used because with it the effects of even and graded tone values are secured with the least amount of trouble. Better tone values may sometimes be obtained by means of pigment and a brush, but skill in their use is more difficult to acquire. In all cases, however, an outline drawing of the model must be prepared in order that the parts of the object that are to be represented in light, shade, and shadow will be properly contoured. In this way, the matter of portraying these values is greatly simplified.

There has been provided, in the outfit of materials, a supply of materials sufficient not only for the work of this Section, but for some of the work in subsequent Sections. However, should the supply of any necessary material run short at any time, a new supply should be purchased at once.

55. Practice Strokes.—Fasten a 19"×12½" sheet of charcoal paper to the drawing board, placing under it several sheets of newspaper, a large blotter, or even a piece of heavy cloth, so that a softer and more resilient surface will be secured. With a stick of charcoal, that has not been sharpened to a point but is in its natural form, practice making strokes in the same manner as the stroke practice work described in this Section. With a full-arm movement, holding the charcoal between the thumb and the first two fingers with palm of hand turned sidewise or downwards, as previously described, draw oblique and curved strokes from the upper right-hand corner to lower left-hand. Draw these strokes lightly at first and then gradually increase the pressure so

49

that heavier and heavier lines result, until finally broad black lines are drawn. At first, white spaces may be left between the lines but, as the pressure on the lines is increased, the

broad black lines may be brought close together and, as their edges blend into each other, a flat tone will be formed.

(a)

56. Practice in Flat and Graded Tones.—For practice, draw a square about 2 inches on each side, and render the surface, by means of parallel oblique lines, in even monotone, as shown in Fig. 34 (*a*). Being able to secure a uniform shade in this manner, attempt spacing the lines more closely so as to produce an even tint without apparent lines except those formed by the tooth of the paper, as shown in (*b*). By using more pressure and a greater number of lines on one side, the tint can þe graded until an effect similar to that shown in (*c*) is obtained. When doing this, the whole square is shaded over in the lightest tone first, and then the darkest tone is applied in the lower left-hand corner. The dark tone is then extended, gradually lessening the pressure with which it is executed, until it blends softly into the lighter tone without any line of demarcation. Generally speaking, but three degrees of shading are made use of in the drawing—the deepest

(b)

(c)

Fɪɢ. 34

shade, half shade, and white. These are then blended one into the other where necessary, in order to produce intermediate gradations.

57. Oftentimes shadows stand out very prominently and in sharp contrast with a very light surface. Other times they will blend into a dark shade so that their edges can hardly be discerned. Owing to the influences of reflected light, shadows sometimes start in a very dark tone and gradually become paler until they softly blend into the lightest tone of the drawing. It is necessary to be prepared to portray any of these conditions; therefore, such practice as the blending of dark into light, as shown in (c), is of the greatest importance.

RENDERING FROM THE MODEL

58. Preliminary Observation of Models.—When making a charcoal drawing of an object, for instance the cube seen at an angle, the first thing to do is to view the object through half-closed eyes in order to eliminate details and to see, in their proper proportions and values, the masses of light and dark values. By viewing it in this manner, the object will appear as in a hazy or blurred photograph. The most prominent value observable in the present case will be the dark value or mass composing the shaded side of the cube and shadow, which blend together without any sharp line of distinction. Next, will be seen the half shade of the left visible side of the cube; and, third, the light value of the top of the cube. This demonstration must be made as this text is read so that the proper method of observation may be practiced.

59. Stages of Rendering.—The rendering of the contours, and light, shade, and shadow values of the object, is done in four steps, or stages. In the first stage, shown in Fig. 35, the outlines of the object and the table line are lightly blocked in, to govern the placing of the tone values.

The second stage, shown in Fig. 36, is the placing, roughly, of the three main values, as seen with half-closed eyes. In this case, by means of bold broad strokes, quite a dark value should be filled in, to represent the shaded side of the cube and the shadow of the cube; next a lighter value should be

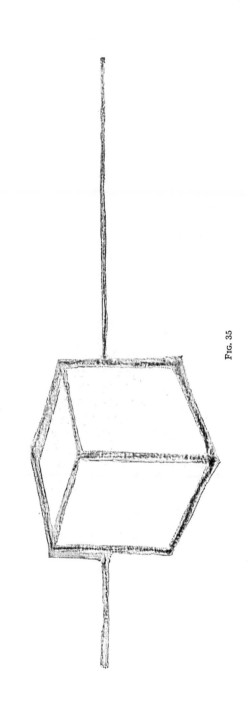

FIG. 35

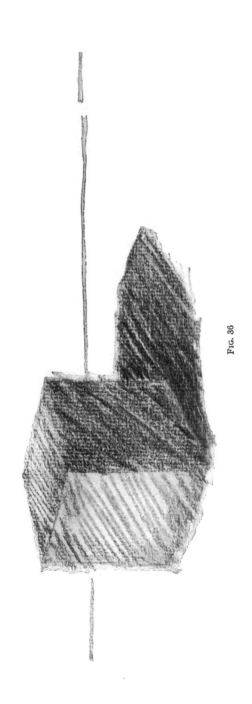

FIG. 36

FIG. 37

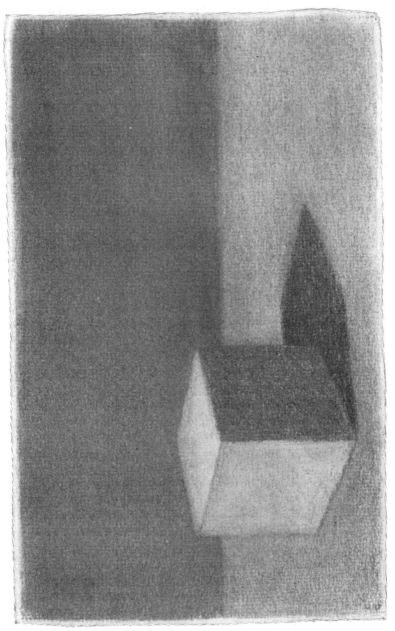

FIG 38

placed for the left visible side of the cube; and, third, a still lighter value should be laid for the top of the cube. No attempt should be made to show sharp dividing edges; the strokes forming one value will overlap those forming another value, and should be left so. No attempt should be made to put in background or foreground. The only work should be that done with the strokes of the charcoal, and should not be touched by the fingers or anything else. The whole operation should take only a few minutes, but should be done with great care.

60. For the third stage the foreground and background values should be put in by strokes only, and the various values and their limits should then be worked up more clearly, as shown in Fig. 37, all work being done by strokes and hatchings drawn directly with the charcoal, untouched and unrubbed by finger or other means.

For the fourth and last stage, as shown in Fig. 38, the evidence of individual strokes or hatchings should be eliminated by lightly rubbing the charcoal with the tip of the finger or with one of the paper stomps. Great care is needed that the rubbing is not too hard or vigorous. The finger or stomp should be passed lightly over the charcoal in a circular motion, which will spread the particles over the paper, touching only the raised lines or dots in the paper; as the sunken spots between the dots remain white, because untouched by the charcoal, they give transparency to the tone. If the charcoal is rubbed hard, it will fill up the sunken portions, thus making a muddy black smudge. After this general softening off has been done, some of the darker values may be given more definite limits, lines of shadow may be put in (such as the dark lines showing where the cube rests upon the table); and other finishing touches may be added with a stick of charcoal sharpened to a chisel edge. Further, there will very likely be planes of light values that have been overlapped by the strokes forming the darker values, which can be evened up by means of the kneaded rubber worked to a chisel edge or to a point. The kneaded rubber can lift off the charcoal, not only for

FIG 39

this purpose but also to take out the dark values to form high lights where needed. A little practice with the kneaded rubber will enable any one to regulate the half lights and high lights by softening off or actually removing the charcoal where desired.

61. Specimen Rendering in Charcoal.—The general description just given for handling the medium will cover its use in the case of any kind of charcoal drawing. In Fig. 39 is shown a charcoal drawing of the group of models, conventionally lighted, in order to illustrate the methods employed in the case of curved surfaces, blending of shaded values, various kinds of high lights and half lights, etc. When making this drawing, the outside contour of the group of objects was first blocked in, then the individual models were lightly drawn at their proper places. The darkest values (shades and shadows), the half shades, and the lights. were then observed through half-closed eyes as before, and placed upon the paper in their proper positions with quick broad strokes of the unsharpened charcoal stick. The four stages of making a charcoal drawing were then passed through.

In the touching-up work it was necessary to use the kneaded rubber to get the proper gradations of light to dark on the cone, the vase, the sphere, the cylinder, and the hemisphere. These differences in tone values were partly secured by the stroke work, but the smooth blending was accomplished by lightly rubbing with the fingers and then lifting off charcoal, where desired, with the kneaded rubber. On the top of the vase, the upper left-hand contour of the cone, the upper left-hand part of the vase, the pyramid, the cylinder, the sphere, and the hemisphere, the brilliant lights were secured by lifting off practically all the charcoal with the kneaded rubber. The reproduction in Fig. 39 is considerably smaller than the original drawing, as can be seen by the reduced scale of the texture of the charcoal paper.

DRAWING EXERCISES

GENERAL INFORMATION

62. In this Section the required drawing plates will consist of drawings made direct from the wooden models themselves, *not* from any text illustrations. These drawing plates are to be prepared so that each plate is first made as an *outline* charcoal drawing of the objects specified, the model itself to be shown properly blocked in and foreshortened, and the contour of the shadow also laid out according to the definite rules of shadow plotting. Then the blocking in, foreshortening, and shadow projection lines will be lightly erased, and the objects and their shadows *rendered* in tone values by means of charcoal, and sprayed with fixatif to prevent the charcoal from brushing off. Directions for "fixing" are on the bottle of fixatif.

The finished rendering must look like a pictorial photographic portrayal of the model (in black, gray, and white, of course), and therefore a foreground and a background should also be included in the rendering. Suggestions for arranging these backgrounds may be had by looking at the backgrounds of Figs. 14, 15, 17, 20, 22, etc. The horizontal surface of the table on which the model rests may be the lighter portion of the background, and the vertical background, the upper part of the study, may be the darker portion, although this arrangement may be varied to suit conditions of light and shade on the model.

63. Each subordinate rectangle on the plates, except in the case of Plate 7–8, is $9\frac{1}{2}$ inches wide by $6\frac{1}{4}$ inches high. To portray the background properly, it should extend to about $\frac{1}{2}$ inch from the edge of the rectangle, thus making the space in each rectangle covered by the background about $8\frac{1}{2}$ inches wide, by $5\frac{1}{4}$ inches high. In this way there will be a generous

FIG. 40

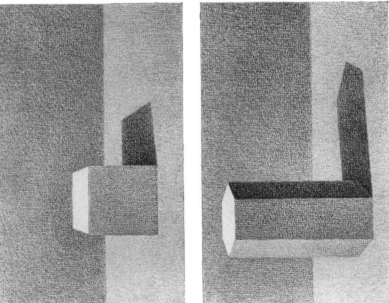

FIG. 41

white margin all around each rendering, separating it from its neighbor. Fig. 40 illustrates, on a much reduced scale, how the first sketch for Plate 1–2 is to be laid out in outline, with the shadow contours accurately plotted. Fig. 41 illustrates, also on reduced scale, how the rendering done over the outline work will appear, being composed of fully rendered studies of the same models that were first blocked in in outline. The other plates are to be prepared according to the same plan; different models, however, are to be used.

Each exercise of the four on each plate should be completed in every respect, sprayed with fixatif, and allowed to dry, before the next exercise on that plate is begun. When working on any exercise, the other three rectangles on the plate should be covered with a sheet of paper. These plates should be sent in to the Schools for examination one at a time as will be directed for each plate.

Starting with the Section on *Light and Shade* the plates will bear double numbers instead of single numbers as in the two preceding Sections. Instead of being known as Plate 1, Plate 2, Plate 3, etc., the plates will be marked Plate 1–2, Plate 3–4, Plate 5–6, etc. This arrangement is made to designate that each plate is practically two stages or processes —an outline drawing and a rendered drawing. The student need simply letter the title of the plate, in each case, exactly as designated in the directions given below.

PLATE 1-2

64. Exercise A, Plate 1–2.—Exercise A is to occupy the upper left-hand $9\frac{1}{2}''\times6\frac{1}{4}\times$ rectangle. To do this exercise, make an outline drawing direct from the wooden model of the full-face cube, making the front face 2 inches square, properly blocked in and foreshortened. Place it slightly to left of center line so that the shadow can be properly accommodated within the rectangle, plot in the contour of the cast shadow accurately, in outline only, according to rules for such plotting given in this Section. Then the exercise should be rendered fully in charcoal, the proper margin of

white paper being left around the rendered exercise, and the rendering sprayed with fixatif. The method of working shown in Figs. 35 to 38 should be employed, the finished Exercise being as in Fig. 41. No outlines should appear around the objects when the renderings are completed. Only charcoal *tone values* should portray the modeling.

65. Exercise B, Plate 1–2.—Exercise B is to occupy the upper right-hand $9\frac{1}{2}''\times 6\frac{1}{4}''$ rectangle. To do this exercise, make an outline drawing direct from the wooden model of the full-face pyramid, making the nearest base line 2 inches in length and the other parts in proportion. Place it in the rectangle so as to accommodate the shadow, and properly plot in the cast shadow. Render the study in charcoal tones, as described for Exercise A, and shown in Fig. 41.

66. Exercise C, Plate 1–2.—Exercise C is to occupy the lower left-hand $9\frac{1}{2}''\times 6\frac{1}{4}''$ rectangle. To do this exercise, make an outline drawing direct from the wooden model of the full-face hexagonal prism standing erect, making the front face 4 inches high and the other parts in proportion. Place it in the rectangle far enough to the left to properly accommodate the shadow cast toward the right. Plot in the shadow accurately. Render the study in charcoal tones, as described for Exercise A, and shown in Fig. 41.

67. Exercise D, Plate 1–2.—Exercise D is to occupy the lower right-hand $9\frac{1}{2}''\times 6\frac{1}{4}''$ rectangle. To do this exercise, make an outline drawing direct from the wooden model of the cylinder standing erect, making the front height 4 inches and other parts in proportion. Place it in the rectangle far enough to the left to properly accommodate the shadow cast toward the right. Plot in the shadow accurately. Render the study in charcoal tones, as described for Exercise A, and shown in Fig. 41.

68. Final Work on Plate 1–2.—When all renderings are completed and are sprayed with fixatif and allowed to dry, the title, Plate 1–2: Light and Shade, should be lettered or written at the top of the sheet, and the name, class letters

and number, address and date placed on the back of the sheet. The plate, protected on its face by a thin sheet of tissue paper, should then be placed in a mailing tube and sent to the Schools for examination.

———

PLATE 3-4

69. Exercise A, Plate 3-4.—Exercise A is to occupy the upper left-hand $9\frac{1}{2}''\times6\frac{1}{4}''$ rectangle. To do this exercise, make an outline drawing direct from the wooden model of the cone, with longer axis of ellipse for the base 2 inches and other parts in proportion. Place it in the rectangle so as to accommodate the shadow. Properly plot in the shadow. Then the exercise should be rendered fully in charcoal, the proper margin of white paper being left around the exercise, and the rendering sprayed with fixatif. The method of working shown in Figs. 35 to 38 should be employed. No outlines should appear around the objects when the renderings are completed. Only charcoal tone values should portray the modeling.

70. Exercise B, Plate 3-4.—Exercise B is to occupy the upper right-hand $9\frac{1}{2}''\times6\frac{1}{4}''$ rectangle. To do this exercise, make an outline drawing direct from the wooden model of the sphere, making the diameter 2 inches. Keep the model in a stable position by a small piece of wax or soap as previously described. Place it in the rectangle so as to accommodate the shadow, and plot this shadow accurately. Render the study in charcoal tones, as described for Exercise A.

71. Exercise C, Plate 3-4. Exercise C is to occupy the lower left-hand $9\frac{1}{2}''\times6\frac{1}{4}''$ rectangle. To do this exercise, make an outline drawing direct from the wooden model of the hemisphere, resting on the curved portion with the flat portion upwards. Make the flat portion 2 inches in diameter and perfectly horizontal. Place the drawing in the rectangle so as to accommodate the shadow, and plot this shadow accurately. Render the study in charcoal tones as described for Exercise A.

72. Exercise D, Plate 3–4.—Exercise D is to occupy the lower right-hand $9\frac{1}{2}''\times6\frac{1}{4}''$ rectangle. To do this exercise, make an outline drawing direct from the wooden model of the vase, with its front height 3 inches and other parts in proportion. Place it in the rectangle so as to accommodate shadow, and plot this shadow accurately. Render the study in charcoal tones as described for Exercise A.

73. Final Work on Plate 3–4.—When all renderings are completed and the drawings sprayed with fixatif and allowed to dry, the title, Plate 3–4: Light and Shade, should be lettered or written at the top of the sheet, and the name, class letters and number, address and date placed on the back of the sheet. The plate, protected by a thin sheet of tissue paper or thin waxed paper, should then be rolled and should be placed in a mailing tube, and sent to the Schools for examination. If all required redrawn and rerendered work on previous plates has been completed, work on Plate 5–6 may be begun.

————

PLATE 5-6

74. Arrangement of Vertical Plane for Plate 5-6. Each model on Plate 5–6 is to be represented as standing to the left of a vertical plane somewhat higher than the object, say about $4\frac{1}{2}$ inches or 5 inches high and about 5 inches or 6 inches long, as shown in Figs. 11 and 19. The intention is first to show the contour of the shadow, and later to show the model's shadow rendered in tone values, as cast upon this vertical plane in conventional lighting. The vertical plane should be arranged so that its lower edge extends backwards at a 45° angle with the plane of sight, and so that it is about $\frac{1}{2}$ inch from the nearest portion of the wooden model.

This vertical plane may be a flat brick wrapped tightly in white paper and standing on one long edge; or it may be the lid of a pasteboard box, the cover of a book, or any convenient light-colored object held in a vertical position by a weight. This vertical plane should be so arranged as to have its lower edge extending backwards toward the left at

about 45°, so that the shadow of the wooden model conventionally lighted will be cast partly onto the table and partly onto the vertical plane, and can be plainly seen while drawing.

75. Exercise A, Plate 5–6.—Exercise A is to occupy the upper left-hand $9\frac{1}{2}'' \times 6\frac{1}{4}''$ rectangle. To do this exercise, make an outline drawing, direct from the wooden model of the cube, seen at 45°, and the vertical plane. Make the drawing full size, as before, the cube having one corner edge toward the observer and being 2 inches high. Place the vertical plane to the right of the model, parallel to the rear right retreating face of the cube, and $\frac{1}{2}$ inch from it. Plot carefully, in outline, the contour of the shadow of the cube cast partly onto the table and partly onto the vertical plane. Then the exercise should be rendered fully in charcoal, the proper margin of white paper being left around the exercise, and the rendering sprayed with fixatif. The method of working shown in Figs. 35 and 38 should be employed. No outlines should appear around the objects when the renderings are completed. Only charcoal tone values should portray the modeling.

76. Exercise B, Plate 5–6.—Exercise B is to occupy the upper right-hand $9\frac{1}{2}'' \times 6\frac{1}{4}''$ rectangle. To do this exercise, make an outline drawing, direct from the wooden model of the pyramid, and the vertical plane, with a corner of the base toward the observer, and seen at 45°. Make the greatest diagonal of the base about $2\frac{3}{4}$ inches and the other parts in proportion. Place the vertical plane, as before, to the right of the model, parallel to the rear right retreating edge of the base of the pyramid, and $\frac{1}{2}$ inch from it. Plot carefully, in outline, the contour of the shadow of the pyramid cast partly onto the table and partly onto the vertical plane. Render the study in charcoal tones, as described for Exercise A.

77. Exercise C, Plate 5–6.—Exercise C is to occupy the lower left-hand $9\frac{1}{2}'' \times 6\frac{1}{4}''$ rectangle. To do this exercise, make an outline drawing, direct from the wooden model of the sphere, and the vertical plane, making the sphere 2 inches in diameter. Place the vertical plane, as before, to the right of the model

and about $\frac{1}{2}$ inch from it. Plot carefully, in outline, the contour of the shadow of the sphere cast partly onto the table and partly onto the vertical plane. Render the study in charcoal tones, as described for Exercise A.

78. Exercise D, Plate 5–6.—Exercise D is to occupy the lower right hand $9\frac{1}{2}''\times6\frac{1}{4}''$ rectangle. To do this exercise, make an outline drawing, direct from the wooden model of the vase, and the vertical plane, making the vase 3 inches high and the other parts in proportion. Place the vertical plane, as before, to the right of the model and about $\frac{1}{2}$ inch from it. Plot carefully, in outline, the contour of the shadow of the vase cast partly onto the table and partly onto the vertical plane. Render the study in charcoal tones, as described for Exercise A.

79. Final Work on Plate 5–6.—When all renderings are completed and the work sprayed with fixatif and allowed to dry, the title, Plate 5–6: Light and Shade, should be lettered or written at the top of the sheet, and the name, class letters and number, address and date placed on the back of the sheet. The plate, protected by a thin sheet of tissue paper, should then be rolled and should be placed in a mailing tube, and sent to the Schools for examination. If all required redrawn and rerendered work on previous plates has been completed, Plate 7–8 may be begun.

PLATE 7-8

80. Blocking in and Rendering for Plate 7–8.—Plate 7–8 contains but one exercise, which occupies the entire plate. To draw this exercise, arrange the eight wooden models in a group, placing the smaller ones in front and the larger ones in the rear, and have them conventionally lighted so that shadows will be cast toward the right and will be inclined slightly backwards, onto the table and onto neighboring models. The grouping of these models must be an original arrangement, and not a copy of any illustration in the text. The nearest models are to be drawn full size and those in the background in pro-

portion. Plot carefully, in outline, the contours of all shadows that are cast. Then the whole study should be rendered completely in charcoal to show all light, shade, and shadow effects. Proper generous margins of white paper should be allowed to remain. The rendering should then be sprayed with fixatif. The method of working shown in Figs. 35 to 38 should be employed. No outlines should appear around the objects when the renderings are completed. Only charcoal tone values should portray the modeling. There should be a white margin.

81. Final Work on Plate 7–8.—The title, Plate 7–8: Light and Shade, should be lettered or written at the top of the sheet, and the name, class letters and number, address and date placed on the back of the sheet. The plate, protected by a thin sheet of tissue paper, should then be rolled and placed in a mailing tube, and sent to the Schools for examination. If all required redrawn and rerendered work on previous plates has been completed, Plate 9–10 may be begun.

PLATE 9-10

82. Character of Exercises, Plate 9–10.—The exercises on Plate 9–10 are to consist of rendered drawings, properly foreshortened, of common household objects whose shapes are based on the cube, the cone, the sphere, and the hemisphere. Suitable objects would be a cigar box, a funnel, a spherical teapot, and a cup and saucer. These should be blocked in and foreshortened as were the wooden models for the preceding plates, and the contours of the shadows accurately plotted as before; after which they should be rendered.

The objects should be drawn about the same size and scale as the wooden models on whose shapes the forms of the objects are based, and should be arranged in their respective rectangles so that all shadows will fall within the limits of the rectangles.

83. Exercise A, Plate 9–10.—Exercise A is to occupy the upper left-hand $9\frac{1}{2}'' \times 6\frac{1}{4}''$ rectangle. To do this exercise, make an outline drawing, direct from the object itself, of a

cigar box or other box with the lid standing open, seen at a
45° angle, properly blocked in and foreshortened. Place it
slightly to the left of the center line of the rectangle to accom-
modate the shadow. Plot in the contour of the shadow. Then
the exercise should be rendered fully in charcoal, the proper
margin of white paper being left around the rendered exercise,
and the rendering sprayed with fixatif. The method of work-
ing shown in Figs. 35 to 38 should be employed. No outlines
should appear around the objects when the renderings are
completed. Only charcoal tone values should portray the
modeling.

84. Exercise B, Plate 9–10.—Exercise B is to occupy
the upper right-hand $9\frac{1}{2}''\times6\frac{1}{4}''$ rectangle. To do this exercise,
make an outline drawing, direct from the object itself, of a
funnel resting on its circular rim, spout pointed upwards, or
of some other conical object, properly blocked in and fore-
shortened. Place it properly in the rectangle to accommodate
the shadow. Plot in the contour of the shadow. Render the
study in charcoal tones, as described for Exercise A.

85. Exercise C, Plate 9–10.—Exercise C is to occupy
the lower left-hand $9\frac{1}{2}''\times6\frac{1}{4}''$ rectangle. To do this exercise,
make an outline drawing, direct from the object itself, or of a
small spherical teapot, properly blocked in and foreshortened.
Place it properly in the rectangle to accommodate the shadow.
Plot in the contour of the shadow. Render the study in char-
coal tones, as described for Exercise A.

86. Exercise D, Plate 9–10.—Exercise D is to occupy
the lower right-hand $9\frac{1}{2}''\times6\frac{1}{4}''$ rectangle. To do this exercise,
make an outline drawing, direct from the object itself, of an
ordinary hemispherical teacup resting in a saucer, properly
blocked in and foreshortened. Place them properly in the
rectangle so as to accommodate the shadows. Plot in the con-
tours of the shadows. Render the study in charcoal tones, as
described for Exercise A.

87. Final Work on Plate 9–10.—When all the render-
ings are completed and the drawings sprayed with fixatif

and allowed to dry, the title, Plate 9–10: Light and Shade, should be lettered or written at the top of the sheet, and the name, class letters and number, address and date placed on the back of the sheet. The plate, protected by a thin sheet of tissue paper, should then be rolled, placed in a mailing tube, and sent to the Schools for examination.

If any redrawn or rerendered work on any of the plates of this Section has been called for and has not yet been completed, it should be satisfactorily finished at this time. After all required work on the plates of this Section has been completed the work of the next Section should be taken up at once.